The Getty Bronze

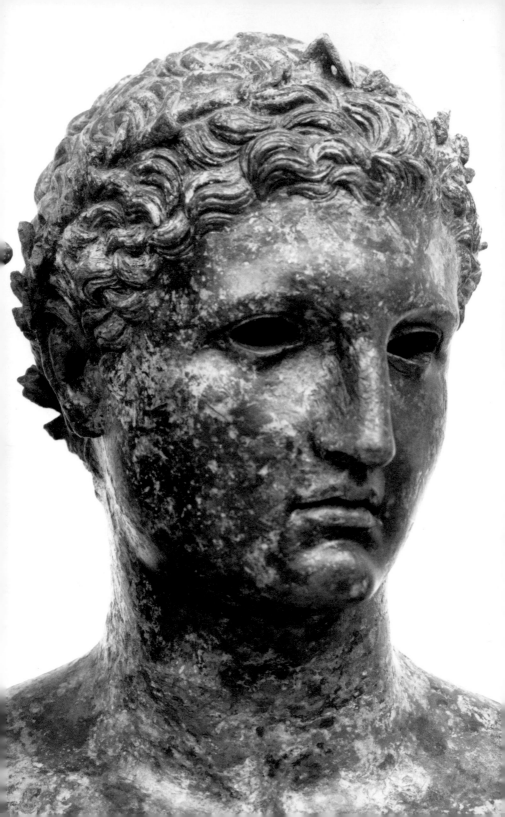

The Getty Bronze
Jiří Frel

THE J. PAUL GETTY MUSEUM MALIBU, CALIFORNIA

© 1982 The J. Paul Getty Museum
17985 Pacific Coast Highway
Malibu, California 90265

Revised edition

ISBN number 0-89236-039-9
Library of Congress catalogue number 82-81305

Library of Congress Cataloging in Publication Data
Frel, Jiří.
 The Getty bronze.

 Bibliography: p.
 1. Getty bronze (Statue) 2. Lysippos—Influence.
3. Bronzes, Greek—California. 4. J. Paul Getty
Museum. I. J. Paul Getty Museum. II. Title.
NB140.F7 1982 733'.3 82-81305
ISBN 0-89236-039-9 AACR2

Table of Contents

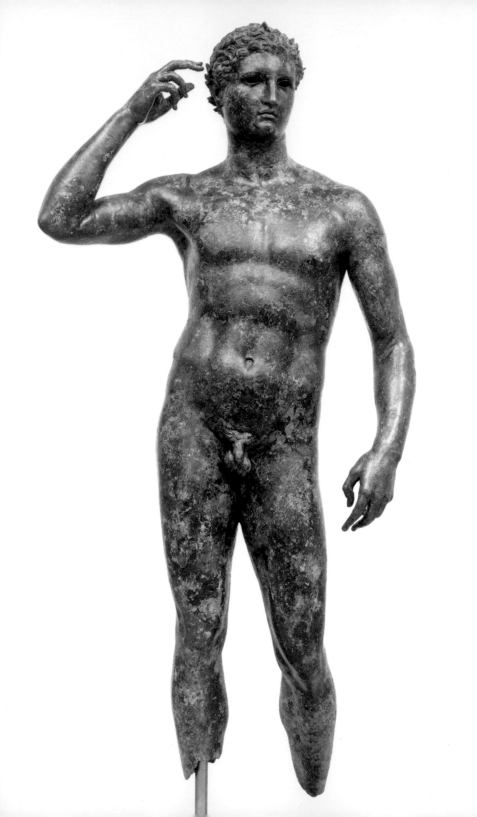

Getty and the Bronze

Early in 1972 J. Paul Getty was advised that a fully conserved original Greek bronze statue of exceptional importance had appeared on the art market. The statue depicted a life-size youth in the act of placing an olive wreath on his head. It was claimed that the work was in all probability by the great fourth century B.C. sculptor Lysippos himself. It was owned by the Artemis Consortium and was being stored with the Munich art dealer Heinz Herzer.

Getty asked Professor Bernard Ashmole if he would travel to Munich and inspect the statue. Ashmole reported enthusiastically and in the years that followed he continued to urge Getty to acquire the statue, claiming that it would make a highly significant addition to the antiquities collection that was being assembled for display in the new museum of his name in Malibu. Getty asked his attorneys to examine all the different legal aspects of the purchase; and a fully satisfactory legal report being produced, he decided to advise the trustees to consider the acquisition. The first offer was rejected by the owners, but when the present curator paid a visit to Sutton Place at the end of 1972, Getty showed him a set of photographs of the *Bronze*. When it was clear that both shared the same intense interest, Getty sent him immediately to Munich for a personal view of the masterpiece.

The curator's impassioned report to the founder restarted the negotiations which had been stalled because of a seemingly prohibitive price. Discussion, however, slowed to a stalemate. A new possibility occurred in the early summer of 1973: the Getty Museum would purchase the *Bronze* together with the Metropolitan Museum of Art. Getty welcomed the idea of sharing a work of art with another institution, extending its enjoyment to a far larger public. He was even ready to accept the risks which the conditions of transport could bring to the fragile bronze statue. The Metropolitan Museum was very pleased at the prospect, and it was ready to lend the Getty Museum important other antiquities. So far, so good. Unfortunately, the negotiations again broke down.

The *Bronze* remained in Getty's mind, a topic of much discussion, and later in 1975 he greatly admired the statue firsthand when it was transferred to London. He would have been overjoyed to know that it finally found its home in Malibu in 1977.

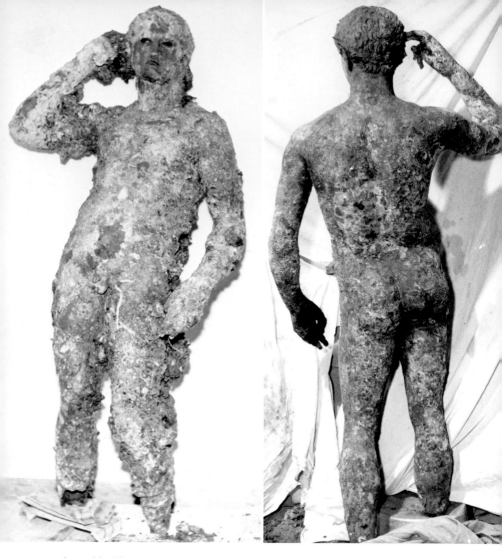

2a and b. The *Getty Bronze* as it came from the sea, front and back, before restoration.

Origins

The first question everyone asks is where does it come from? The statue speaks for itself. Its appearance before conservation (figs. 2a and b) shows that it must have been in the sea and that it spent a long time there. Not only a substantial corrosion of the metal but also the thick layer of incrustation, including shells of sea animals, indicate that it must have been under water for centuries. It was good luck that it took on so much concretion, for that prevented the further degradation of the metal from the action of the salt water.

Finds of classical Greek bronzes and many Roman bronzes have been made all around the Mediterranean Sea. Greek fishermen found a splendid fifth century Zeus off Cape Artemision. The mid-fourth century B.C. *Marathon Boy* came from the bay of the same name along with a Hellenistic boy jockey and his horse. Sponge divers at the turn of the century discovered a shipwreck not far from the tiny island of Antikythera that contained a fourth century bronze youth (fig. 3) together with some later sculptures. Investigation of another shipwreck on the coast of Turkey near Bodrum (ancient Halikarnassos) brought to light a torso of a bronze draped goddess and some later statues. Recently the Mediterranean northeast of the Straits of Messina, on the shores of Riace, has yielded two splendid over life-size bronze male statues from the mid-fifth century, probably connected with the great master sculptor Pheidias (fig. 4). These treasures, after a lengthy conservation, are to be seen today in the museum of Reggio di Calabria to the joy of the public and specialists. The depths of the sea near the Tunisian coast at Mahdia also revealed, about the turn of the century, a cargo of ancient marbles and bronzes, including the statue of Eros leaning on a herm (fig. 5). It is the work of the neo-Attic sculptor Boethos who was clearly inspired by a Lysippan work not dissimilar in stance to the *Getty Bronze*. A Roman replica of the herm is in the Getty Museum (fig. 6).

Simply looking at the *Getty Bronze* and seeking to probe its origins, it can be said that most large-scale bronzes come from ancient shipwrecks. This must have been the case with the Getty statue. The thick incrustation that had to be removed suggests many centuries under water, so it is not likely that a medieval or late Venetian sailing ship carried it as a spoil of war or scrap metal. More probably a Roman

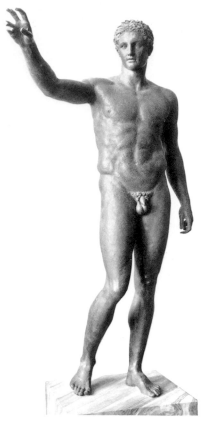
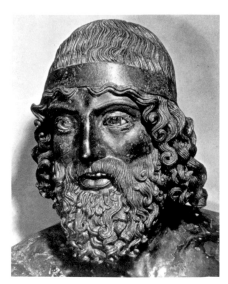

3. The *Antikythera Youth.* Athens, National Museum.

4. The *Younger Warrior,* from Riace. Reggio di Calabria, Museum.

transport foundered while carrying the Greek masterpiece for the pleasure of a Roman general or emperor in the first century B.C. or A.D., the golden age of Roman art collecting.

But where did the statue originally stand in antiquity? The olive crown identifies the youth as a victor in the Olympic games, and thus the first thought is of Olympia itself. An Olympic victor regularly had his statue erected in that sanctuary, sometimes soon after his victory but more often several years later. Usually an identical or similar monument was also set up in a public place in the victor's native city. The Getty statue may present a more complicated problem.

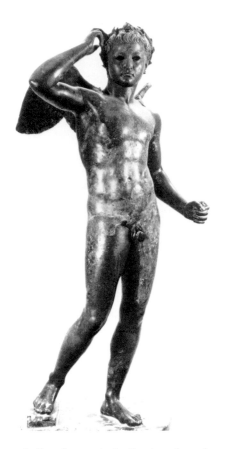

5. *Eros Enagonios* by Boethos, from the Mahdia shipwreck. Tunis, Musée Bardo.

6. **Herm**, Roman replica of figure 5. Malibu, The J. Paul Getty Museum (79.AA.138).

The *Bronze* does not represent a simple athlete but more probably a young prince from one of the royal houses immediately succeeding Alexander the Great (pp. 18–22 below). His statue as an Olympic victor could thus have been dedicated anywhere in the ancient Greek world. No Greek sanctuary, no public place, no Greek city, from Magna Graecia to the actual Greek mainland and islands to Asia Minor, the Levant, or Alexandria can be excluded as the possible original home of the *Getty Bronze*.

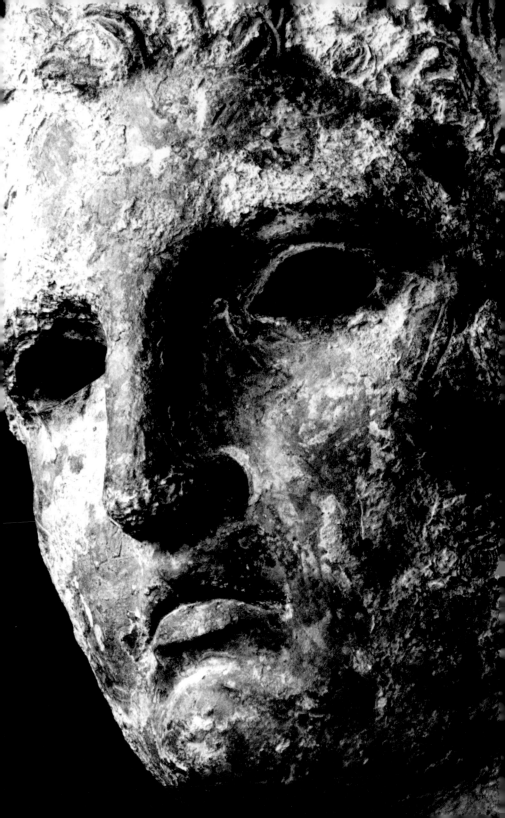

Conservation

It is really a miracle that the statue survived under the sea for so long. Another miracle has been accomplished in its conservation by Rudolf Stapp, one of the most competent specialists of ancient bronze. Before he was entrusted with the piece, some less capable hands tried to take away the thick layer of agglomeration all over the surface. In some places the metal was scratched, but fortunately the damage was not serious (see fig. 7). It took three months for the whole surface to be cleaned mechanically with a scalpel. Detailed examination of the surface then showed that under the concretion the statue was totally covered with a green patina formed of basic copper chloride, and under the patina by a reddish-violet layer of crystallized copper oxide. Under this was a very thin layer of dark color, partially visible now on the statue, which is tin oxide. Below this layer is the bronze itself. Inside the statue some black spots of copper sulfide were found. The alloy itself consists of 89% copper, 10% tin, small amounts of antimony, and tiny traces of lead, iron, silver, nickel, and cobalt. The statue is 151.5 cm. (59½ in.) tall; with the missing feet it would have stood about 170 cm., a good height for a fourteen- to sixteen-year-old boy. X-rays demonstrated that there were no cracks in the statue, other than the separation of both arms, and that the core was still mostly in place except for the right leg where only the outer layers survived. In order to protect the statue, the core was completely removed to lessen the chance of damage by humidity, which it attracts and retains. This procedure required a month's work. The core material was examined in detail. Part of it was submitted for thermoluminescence dating, and some of the wood from it was examined by the carbon 14 method. Both tests confirmed a pre-Roman date for the statue.

The statue was then exposed twice to artificially increased humidity. The initial exposure produced new spots of bronze disease, not only on the already affected areas but also on some other areas that had looked healthy to the naked eye. Chlorides and other salts

7. The *Getty Bronze,* detail showing scratches on the face, perhaps from an attempt to remove the eyes.

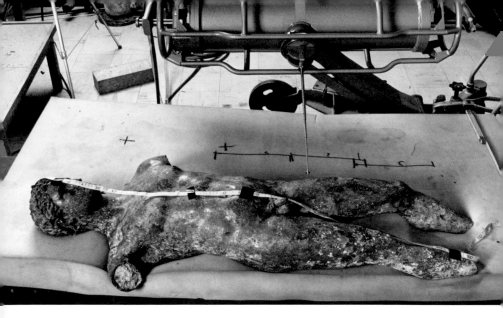

8. Conservation photograph, showing the *Getty Bronze* being studied before conservation.

present in the bronze combined in the presence of the moisture to activate the interaction of salt and metal to stimulate the diseased spots. The copper part of the bronze mineralized, turning to light green copper chloride, a powdery, scaly substance which, left untreated, falls off, causing loss of surface and irreparable damage. To neutralize the active corrosion, the statue was immersed for hours in a heated solution of sodium sesquicarbonate; the liquid took on a strong greenish color from the diluted copper chlorides. The treatment was stopped and then repeated in a vacuum to enable the solution to reach all interior layers of corrosion without washing anything out. The process was repeated twice after the artificially increased humidity test in order to prevent any recurrence of bronze disease.

To support the statue, an inoxidizable steel bar was next embedded in the shoulders with cushions of synthetic resin. Today the statue is in stable condition, but it must be kept in an environment with humidity under thirty-five percent, especially since Malibu is near the ocean.

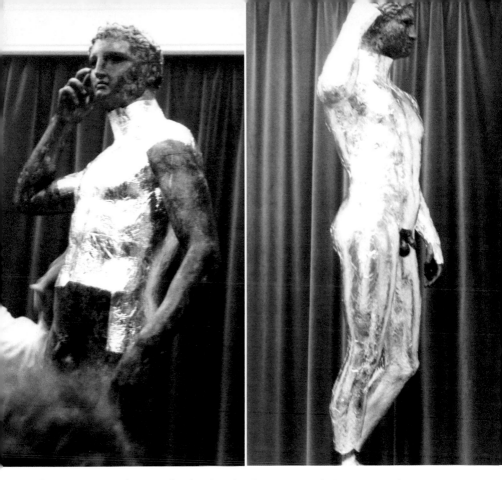

9. Conservation photographs showing the *Getty Bronze* during conservation.

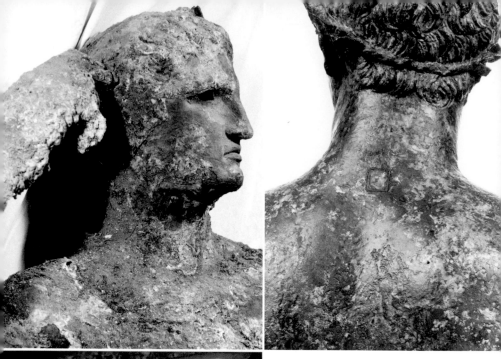

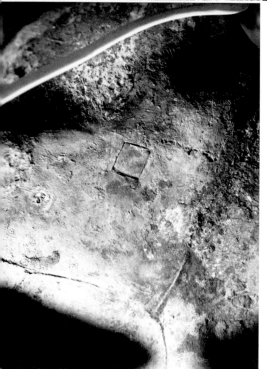

10. The *Getty Bronze*, detail of the head before conservation.

11. The *Getty Bronze*, rectangular plug on nape (retouched around plug).

12. Detail of the interior of the *Getty Bronze*, showing the joins of the wax plates for the final modeling.

Making the Statue

The examination during conservation allowed many more observations that helped to explain how the *Bronze* was modeled and cast. The creator of an ancient bronze statue proceeded in the same way as a sculptor in the Renaissance or even one in modern times. The main difference is that the ancient artist was himself responsible for the delicate technical process of casting, a task which modern artists usually leave to specialized craftsmen. The first step was to build an armature or support. Modern sculptors use iron bars or wires; the artist of our statue used mostly reed sticks. Two or three reeds were placed parallel in the legs. In addition, a thicker wooden stick went through the chest and throat to the level of the nose. Around this armature was packed the rough center of the core, which was then extended by reeds through the arms. A few small reed fragments are still extant in the core debris, and we can trace the existence of additional reeds by their negative imprints on the inside of the core material.

Around this reed support was packed a hard mixture of pebbles, glue, pistachio nut shells, some pottery sherds, and even ivory fragments. This conglomerate also supported the joins of the body and arms. The mass of the core was built from a mixture of loam and sand. In the big sections of the core, such as that inside the torso, the structure of the inner core was rather loose. It was covered by slightly denser yellowish sand. On top of this were layers of dark grayish, loamy sand of thicker texture. The final coating of the core as preserved was a layer from two to six millimeters, of considerable density, a black clay almost as fine-grained as potter's slip. It covered the whole of the core and during the casting process reached an especially hard consistency inside the head, arms, and legs. The sculptor shaped the statue with a final layer of fine clay and executed the last subtle modeling in the upper part of this final coating.

The final modeling was done in wax plates or sheets, which the artist applied to the surface of the statue: their joins are still perceptible inside the bronze. During this delicate operation, the whole statue was supported at many points. These supports were removed and plugged by small rectangular wax plates which were then smoothed. One such rectangular plate on the back of the neck (fig.

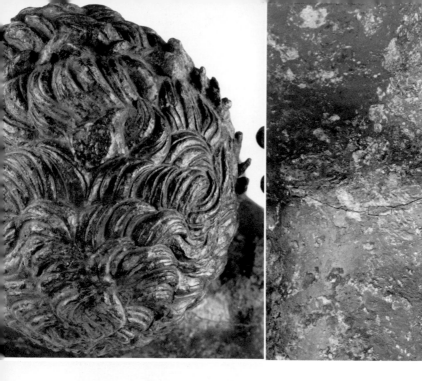

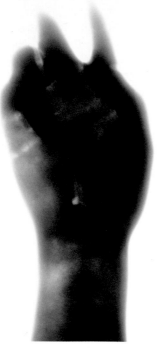

13. The *Getty Bronze*, top of the head showing chasing and the protrusion of the main vent (?) (retouched around vent).

14. The *Getty Bronze*, repairs to lower back (retouched to show more clearly).

15. The *Getty Bronze*, x-ray of hand showing that it is solid cast.

11) may have supported a special rod to hold the statue in a vertical position. This technical peculiarity is shared by at least two other fourth century bronzes: the *Marathon Boy* and the *Antikythera Youth* (fig. 3). Iron nails (twenty three were found in clearing the core) were put through the wax layer and into the core. The nails also protruded outward to fix the core in position with the external mold. This was so that an air space would be left by the melted wax as it ran out, before it was replaced by the molten bronze. This is why this technique of casting is called the "lost wax" process. It may be emphasized that the complete statue was cast in one piece. The most delicate parts—the hands and ears—are cast solid, having been modeled entirely in wax. The face and hair also have thicker walls, reflecting the artist's most detailed attention during the final work.

Just prior to casting, at the stage of modeling the wax, two important changes were made. The original position of the right arm was stretched higher over the head, possibly with the intention of holding the crown. The artist cut through the wax layer and moved the core, introducing a quantity of new material to adjust the position of the arm and hand closer to the head. The artist must also have been dissatisfied with the height of the neck, because another small portion of core material was inserted there to raise it a little. Both operations can be traced in the joins of additional wax sheets as they appear inside the cast (fig. 12).

The statue was next covered with a coat of loam and sand to make the outer mold. Channels were established for both the pouring of the metal and the escape of the air. Slow heating allowed the melting wax to escape and also fired the core and mold to a stable condition. The artist then prepared his metal mixture in several small containers, pouring it quickly and successively into the form. The whole was allowed to cool slowly before the coat was removed.

The irregular surface was then cleaned (today wire brushes are used for this). Some details like the fine design of the hair may have been enhanced with supplementary chiseling. The iron spacer nails as well as the bronze pegs resulting from the casting channels were cut off. One protrusion, possibly of the main vent, remains on the top of the head, where it would have been out of sight when the statue was set up (fig. 13). A similar protrusion appears not only on the bronze *Marathon Boy* but also on the marble replica of Lysippos' *Apoxyomenos* in the Vatican (fig. 47). The Roman copyist who reproduced the original did not understand that this was just a casting

channel that had not been removed; its presence, however, increases our confidence in the ancient copyist's precision and the accuracy of the three-point copying technique.

Next the statue was chased. Nipples and lips were added in copper that survives; the red color must have contrasted with the original golden yellow of the bronze surface. There may have been some silvering of the olive crown and possibly even some color to enhance other details, for example the cheeks. The eyes, now empty, were inserts of crystal and glass paste. Above them a finely fringed sheet of bronze would have provided eye lashes.

The casting holes and some minor defects were repaired by filling the areas with small rectangular plates of bronze cut in wedge shapes which enabled them to be firmly fixed in place. One of these repairs has fallen out of the lower left calf. A row of them is easily seen on the waist of the right back (fig. 14); in this area, gas captured in the liquid bronze may have produced some tiny bubbles. The inserts were embedded into rectangles cut in the bronze and then carefully hammered to surface level. Of course the fingers, where the flow of metal could have caused even more flaws, had been cast solid (fig. 15).

Several technical problems need further discussion. The processes described above might have been somewhat more complicated if composite molds had been used, a technique well known to Greek sculptors, probably already in the fifth century B.C. Specialists will study the *Getty Bronze* in detail in the future, but it is already established beyond doubt that the statue was cast in one piece, not assembled from several parts cast separately.

Finally, the statue was fixed on a base with the help of lead pegs probably melted into the open sole of the right foot and into the tips of the toes and the ball of the left foot. An inscription would have been incised on the base with the names of the young victor, his father, perhaps his home city, and most probably the artist.

Looking at the Statue

A nude youth, no longer a boy and not yet a man, has just placed an olive crown on his head with his raised right hand (figs. 16 and 17). He stands with his weight on his right leg, the hip slightly forward and the right shoulder slightly back. His left foot, placed quite far back and supported only on two toes, moves the left flank back slightly. To complete the elaborate balance, the left shoulder is thrust forward. The left arm today hangs down apparently meaninglessly, but from the position of the hand and traces in the hollow of the elbow, it seems that a bronze palm branch, another attribute of the Greek athletic victor, was once held here. A grave relief from the Kerameikos in Athens and a Roman marble copy of a Greek bronze athlete statue in Istanbul also represent victors holding palm branches in their left hands.

With the head turned slightly to the left and inclined, the sculpture is given the last touch of balance. The lower abdomen protrudes slightly in a mark of the Lysippan stance. The statue is presented fully in the round, both in conception and in details. The piece does not suggest an inherent motion, but it invites the viewer to walk around it. The back (fig. 18) lacks the subtle nuances of the front: the modeling is still fine but without the ultimate spark of life. The inescapable conclusion is that the statue must have stood in or against an architectural frame that provided a focal background, perhaps emphasizing the rank of the youth. We can imagine a kind of open portico that may have sheltered a whole group of statues, a family monument like the Lysippic group of the Thessalian dynasty erected in Delphi and Pharsalos in honor of their athletic achievements. Still clearer would be the analogy of the Philippeion at Olympia. The stance of the *Bronze* does not in any way preclude the presence of another figure. There might have been at least an image of the father, proud of the prowess of his son and simultaneously commemorating his own past athletic achievements.

The pose looks extremely spontaneous and natural, but, as always

16. The *Getty Bronze* (page 16).
17. The *Getty Bronze* (page 16).
18. The *Getty Bronze* (page 17).

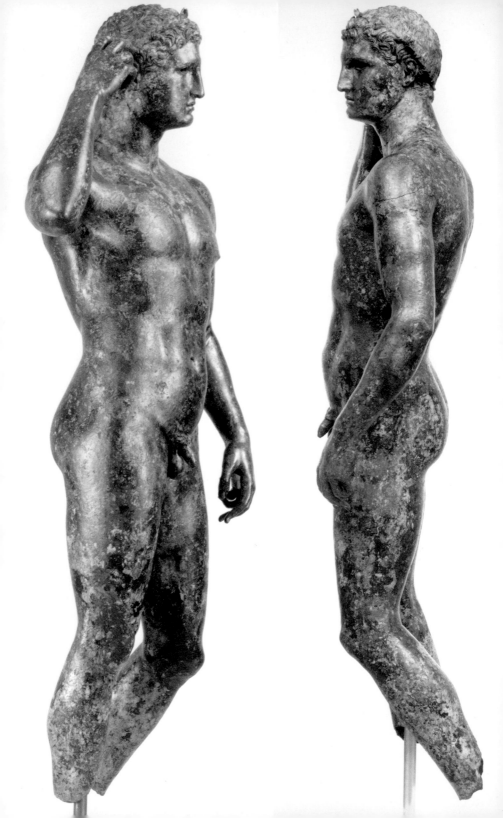

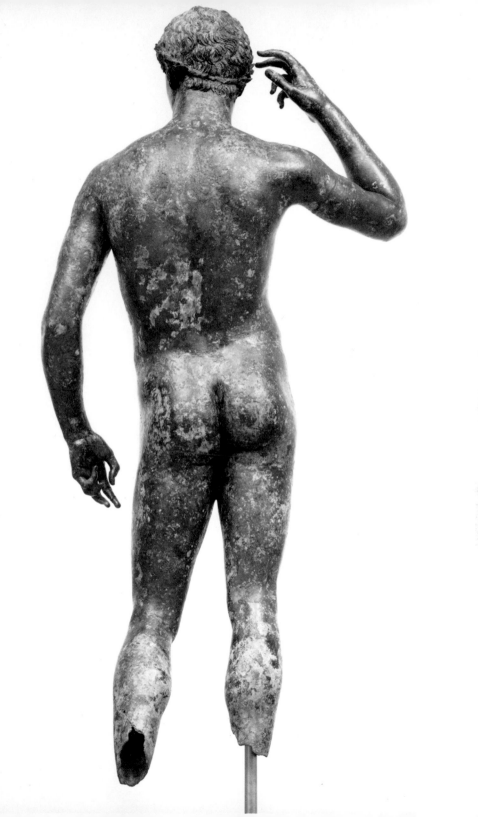

in Greek art, it is artificial. The stance, in particular, is sophisticated in spite of the natural appearance. The easiest way to perceive this is to try to reproduce the pose with your own body: one succeeds with difficulty, and the result is rather ridiculous. The temptation would be to conceive of the pose as frozen movement. It is not, but is instead an abstract formula intended to express more than simple physical motion. It aspires to embody the concrete substance and, at the same time, to express something timeless. The rendering of anatomy attempts to be much more detailed, more precise, more rich, and more biologically natural than classical sculpture was before this time (fig. 19), but the body is not an anatomical illustration at all. The choice of details, both on the surface and in the disposition of the muscles, in their consistency and in their relationship to the bones, is significant for the imagery. It is not what the artist sees, but what he knows, that is presented. He reaches our emotions by appealing to reason, the divine *nous*.

The representation of anatomy is of some importance for identifying the subject. For all the exercised muscles, the body and limbs appear rather bony, still not fully developed. The trainer of the young athlete knew the meaning of the most Greek of virtues, moderation, and designed the exercise program to be in harmony with the nature of the growing youth. The sculptor emphasized his subject's age with artistic mannerisms: the delicacy of the wrists, the overemphasized points of the elbows, the extremely skinny, sharp fingers, ending in tiny tips with minuscule nails (fig. 20). All this points very subtly to the presentation of a youth: no longer a boy and not yet a man. The youth's age, perhaps fifteen for Mediterranean stock, is corroborated by the pubic hair that has just started to grow.

The youth is an athlete. It is not only the crown which designates him as such (fig. 21) but also comparison with countless late classical and early Hellenistic images. These illustrate even the gods as light, wiry runners or heavyweight athletes like boxers (such as the *Farnese Herakles,* fig. 44 below). The precise definition of this youth's athletic specialty eludes us. Surely he was not a boxer: the ears are free of any of the characteristic mutilation that accompanies heavy pummeling. The most noble of the Olympic disciplines, the simple race, may have been his specialty; but nothing indicates it either in the stance or in the muscular configuration. It should be remembered that at Olympia the *agones* took place in three categories, not only for men and boys but also in a third category for youths.

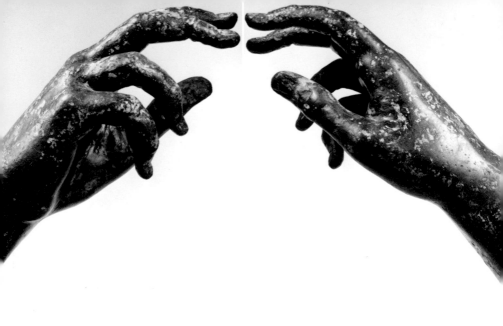

19a–b. The *Getty Bronze*, details of right hand.

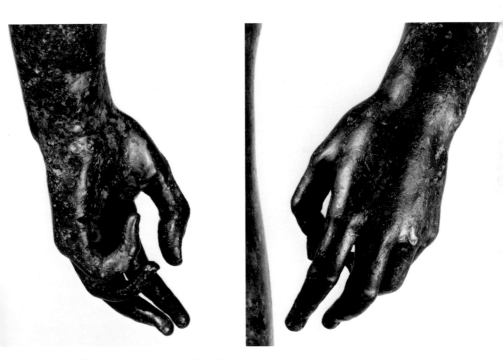

20a–b. The *Getty Bronze*, details of left hand.

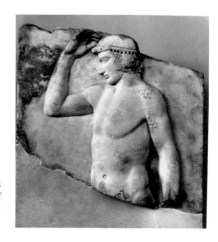

21. **Athlete crowning himself** (the holes for attaching a metal wreath). Marble relief from Sounion, early fifth century B.C. Athens, National Museum.

There are other specific indications about the character or activity of the youth, but the first thing emphasized is the general fact of victory. The outward signs of success are the attributes of crown and palm, but the achievement shines from every little detail; and it is evident that the classical world has already been left behind. In the *Kyniskos* of Polykleitos (fig. 22), and in a portrait of a victor in the boys' boxing match one statue from the Thessalian ex-voto connected with Lysippos at Delphi (fig. 23), the victor's stance at the moment of securing the supreme sign of his victory expresses a completely different psychological approach. To describe athletic victors, the classical Greeks used the word *aidos,* meaning modesty but implying much more. The head was traditionally bowed down, confirming the humility of the winner. Honor was received this way while avoiding any suspicion of *hybris,* not acceptable to the gods and offensive to fellow citizens. But in the late fourth century Alexander (356–323 B.C.) had passed like a meteor through Greek skies, and the universe would never be the same. From this time on any dream, any aspiration, was admissible. No more a boy, not yet a man, this ephebe does not pretend humbly to be like anybody else. No longer shy of having won, he looks directly into the sun. He does not accept, he claims: *amor fati.*

There is another characteristic of the statue which a modern viewer can perceive most easily in the head (fig. 24). The face is no longer of a traditional beautiful but impersonal type. The neoclassical illusion implanted in our minds of the perfect Greek profile is here com-

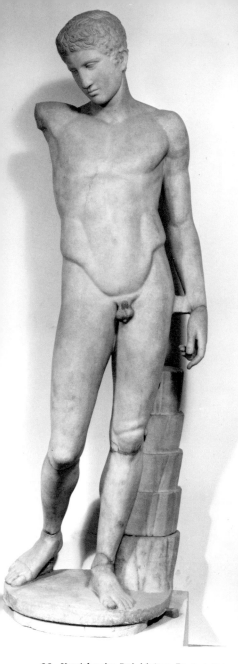

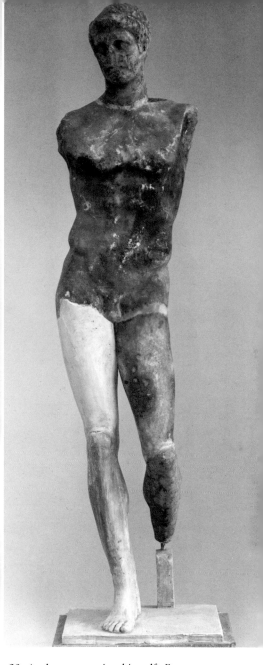

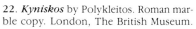

22. *Kyniskos* by Polykleitos. Roman marble copy. London, The British Museum.

23. **Agelaos crowning himself.** From a monument in Delphi, a contemporary marble replica of a bronze group by Lysippos in Pharsalos (ca. 335 B.C.). Delphi, Museum.

21

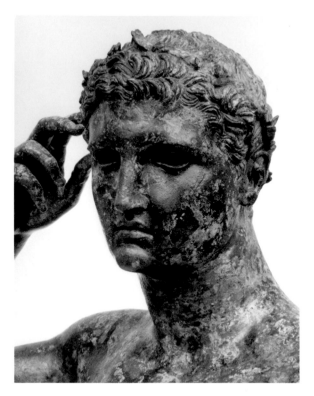

24. The *Getty Bronze.*

pletely denied. More than this, both profiles (figs. 25 and 29 below) at first glance are contradictory to the conception not only of beauty but even of the well-planted classical *kalokagathia.* Instead, the claims of individual likeness are clearly revealed. What has been seen in the face can also be perceived in the body, which also deviates from the traditional artistic *Kanon* and creates an individual appearance. The Greeks were very sensitive to the new approach in the statue as a whole. For us, individual appearance is limited mostly to the face; for them, it pervaded the whole figure. From the stance to the features, the claim is not to be *agathos,* a well-bred citizen like another, but to be superior. The immediate conclusion suggests identification with a very young scion of one of the royal families that succeeded Alexander.

The Identity

One would like, of course, to discover the real name of the *Getty Bronze*. This may be possible one day, but more time and much more research are necessary. The starting point for the iconography of the immediate successors of Alexander are some coin portraits and a number of indeterminate sculptural portraits, surviving in Roman copies of varying quality. Comparison between the two categories is difficult, and the results to date have reached a general consensus only in a few cases.

Among the images which have not yet found a name, there is one example, fortunately on loan for some time to the Getty Museum, for which a direct comparison with the *Getty Bronze* seems to be fruitful. It is a herm, slightly under life size, carved probably in the second century A.D. by an unpretentious artisan of Roman times somewhere in western Asia Minor from a local marble (figs. 26, 30, and 34). The features seem to be the same (with the left and right orientation of the herm reversed). Comparison of the left profiles (figs. 25 and 26) looks particularly promising. Of course, the difference in quality, of material, and of date is enormous; but the line of the chin, the angle of the cheekbones in relation to the orbits, and the proportions result in the impression of the same personality. The evident discrepancies may derive to a great extent from the different conditions of the pieces and the different ages of the sitters. The herm is no longer a flourishing youth but a man in his late thirties at least, his flesh turned heavier with age, shown not as a victorious athlete but as a king. The olive crown is replaced by a large fillet tied at the nape with the ends hanging over the shoulders, the distinctive royal insignia. The individual characterization is rather timid—a feature probably inherent already in the original; a general, ideal image of the ruler was intended rather than a picture of his actual likeness. The style, based on Lysippic proportions, points to a later date for the original, perhaps in the first decade of the third century, while the *Getty Bronze* must have been cast about 320 or slightly later.

The same image seems to have survived in at least one other Roman replica, also a herm, found at Ephesus (fig. 31). The ruler's popularity must have survived well into Roman times.

Another portrait head, also smaller than life size but an original from the early third century B.C. (figs. 28, 32, and 36), was earlier compared with the *Getty Bronze*. The head is in Pentelic marble, hence carved in Athens, and belongs to Smith College which generously lent it to the Getty Museum for more than a year in 1978–1979. Professor Phyllis Lehmann, in a recent publication, emphasizes the evident differences of the features, especially in the frontal views. The profiles (the upper left lip of the marble is a restoration) seem to suggest a close affinity if not the same personality. Professor Lehmann proposed to recognize in the Smith head an image of Demetrios Poliorketes (336–283 B.C.), a man who by nature and genius was closer to Alexander than any other successors of the great Macedonian. This may be correct, even if the rounded face of the only generally accepted portrait of Demetrios, a marble herm found in the Villa dei Papiri (fig. 37), is closer to the proportions of the *Getty Bronze* than to the elongated features of the Smith head. The sitter must have been popular in antiquity; a copy carved during the first century B.C. in Athens survives in the Ny Carlsberg Glyptotek in Copenhagen (figs. 27 and 35).

The Smith College head may be well compared with an earlier original marble head (ca. 330 B.C.) from Pharsalos (fig. 40; lost? it cannot be traced either in the local Antiquarium nor in the museum in Volos). Clearly Lysippan characteristics remind us that the original of the Thessalian ex-voto preserved in a contemporary marble copy in Delphi (fig. 23 above) was cast by Lysippos for Pharsalos. Another comparable marble Lysippan head of Greek workmanship from the fourth century B.C. is in Olympia (figs. 39 and 40); it must have been a victorious athlete.

Could the *Getty Bronze* commemorate a precocious athletic success of the starcrossed conqueror? One would like to accept the identification, but comparison with the coins bearing the portrait of Demetrios Poliorketes is not convincing. There is some general similarity, but the character of the man appears rather different.

More time and much more work are necessary to discover the real name behind the *Getty Bronze*.

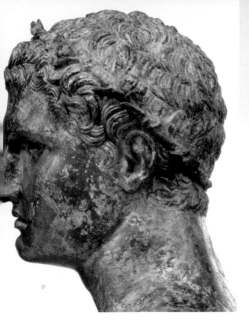

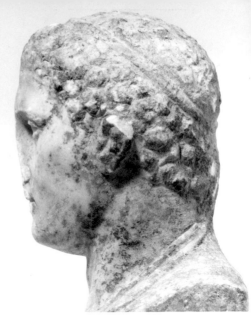

25. The *Getty Bronze*.

26. Herm of a Hellenistic ruler. Malibu, The J. Paul Getty Museum (L80.AA.82).

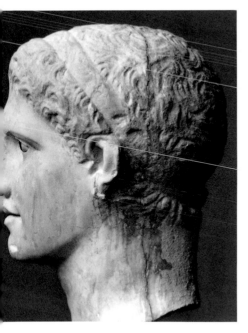

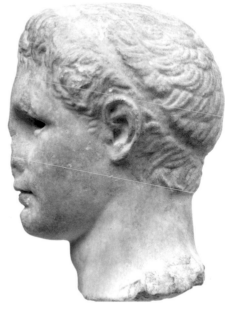

27. Head of an athlete. Copenhagen, Ny Carlsberg Glyptotek.

28. Head of an athlete. Northampton, Smith College.

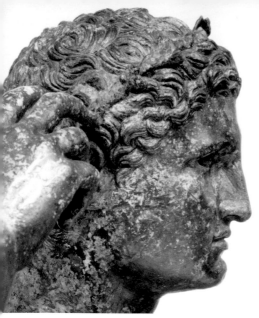

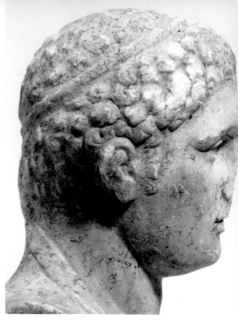

29. The *Getty Bronze*.

30. Herm of a Hellenistic ruler. Malibu.

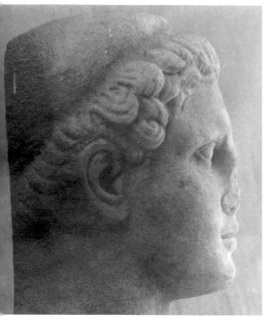

31. Herm of a Hellenistic ruler. Ephesus, Museum.

32. Head of an athlete, Northampton.

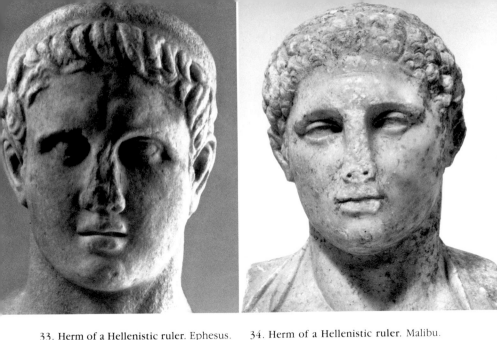

33. Herm of a Hellenistic ruler. Ephesus. 34. Herm of a Hellenistic ruler. Malibu.

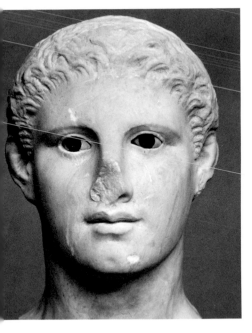
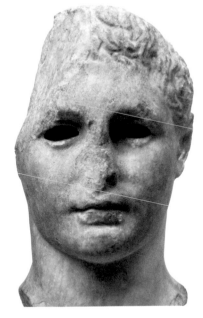

35. Head of an athlete. Copenhagen. 36. Head of an athlete. Northampton.

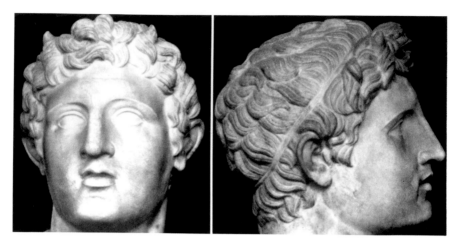

37–38. Herm of Demetrios Poliorketes. Naples, National Museum.

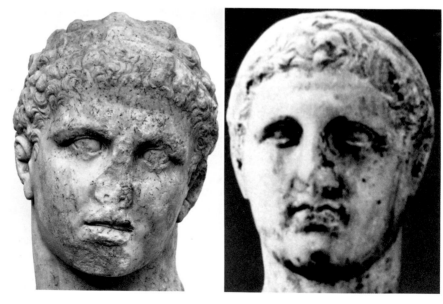

39. Head of an athlete. Olympia, Museum.

40. Head of an athlete from Pharsalos.

Lysippos

The art of the *Getty Bronze* points to Lysippos, the court sculptor of Alexander the Great. Before pursuing this attribution, something should be said in general about the whole of the great sculptor's career. As with other masters of Greek art, our knowledge is scanty, coming from brief mentions in different Greek and Roman authors, from some inscriptions mentioning his name, and from possible identifications of his work among later copies made to suit the taste of Roman collectors. The main literary source is Pliny, a noble Roman who fell victim to his own insatiable thirst for knowledge at the eruption of Vesuvius in A.D. 79. In his *Natural History,* in chapters dealing with metals and stone, he includes information about Greek sculptors excerpted from earlier writers now irretrievably lost to us. He mentions several works of Lysippos which modern scholars have tried to identify with later copies. If it is true that the *Getty Bronze* is Lysippos' work, we have an original masterpiece of a great artist, and both Lysippos and the statue will benefit.

Lysippos was born about 390 B.C. in the northern Peloponnesian city of Sikyon. His father had the same name and may have been a bronze caster, since this occupation is ascribed to his son before he became a sculptor and it was usual for a son to follow the craft of his father. Lysippos worked exclusively in bronze, probably introducing many technical innovations about which tradition is silent and about which we know practically nothing.

Lysippos lived a long and active life, active from at least 369 until the end of the century. A late epigram addresses him as a very old man. This may be confirmed by a portrait of Seleukos Nikator (c. 358–280 B.C.) attributed to Lysippos by ancient sources. On the statue base, the inscription is said to identify him as king, a title he took only in 306, when Lysippos would have been over eighty. However, the title may have been added at a later time, a not uncommon occurrence in ancient inscriptions. On the other hand, if the portrait of Seleukos preserved in a replica found at the Villa dei Papyri (fig. 41) is the Lysippos portrait, the sitter appears very old.

Another anecdote tells us that Lysippos died in straitened circumstances because he worked on the same statue over and over. It is also said that he created over 1500 works, several of them sculptural

groups. The two traditions may not be contradictory. Lysippos was very productive, but perhaps in quest of perfection he constantly reworked and improved his sculptures. The adjustments to the neck and right arm of the *Getty Bronze* would be consistent with this kind of meticulousness.

The first sure date in Lysippos' career is about 369 B.C., when his statue representing Pelopidas, a famous Theban statesman and general, was dedicated at Delphi. Today only fragments of the inscribed base survive. In addition, he is known to have made several statues of victors for the precinct at Olympia before the middle of the fourth century; and he continued to make many statues of victorious athletes throughout his career. The base of one with contemporary reliefs survives in Olympia, but it is doubtful that the reliefs are by Lysippos' hand. He may then have spent about ten years in Tarentum, the rich Greek city in Southern Italy. Sources relate that his colossal bronze *Zeus* in Tarentum's marketplace was almost eighteen meters high.

In the critical years when Alexander's father Philip was conquering Greece, Lysippos worked for a ruler of Thessaly. Somewhere between 338 and 334 a statuary group of the Thessalian dynasty was erected at Pharsalos. Probably at the same time, marble copies of it, executed possibly by his workshop, were dedicated in Delphi (figs. 23 and 42). Part of the inscription in Pharsalos was seen in the last century. The pedestals of the sculptures in Delphi and most of the marble copies are still extant, provoking endless discussion about their relationship to Lysippos' art. In addition, several more inscribed signatures of Lysippos from various sites are known, some of them from his lifetime and some are Roman reproductions.

At an indeterminate date, Lysippos produced for his native city of Sikyon another *Zeus* and a *Herakles*. For the Pompeion in Athens he cast a statue of *Sokrates,* probably seated, which was erected by the Athenians, repentant more than eighty years after the death sentence they had imposed on their best citizen (fig. 43).

Several images of Herakles can be traced back to Lysippos. The most famous is called, after a well-known copy, the *Farnese Herakles,* with the tired hero holding the apples of the Hesperides behind his back and leaning on a support (fig. 44). Another colossal seated *Herakles* was executed for Tarentum. His *Kairos,* the allegorical name of Opportunity, the appropriate occasion, was one of his most popular works in antiquity (fig. 45). This beautiful winged youth survives today in only two rather miserable reliefs. Lysippos' *Eros Bending*

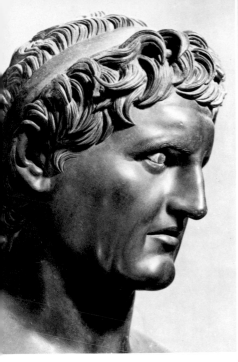

41. Portrait of Seleukos Nikator. Naples,
National Museum.

42. Agias from the monument at Delphi.
Delphi, Museum.

43. Portrait of Sokrates. Rome, National
Museum.

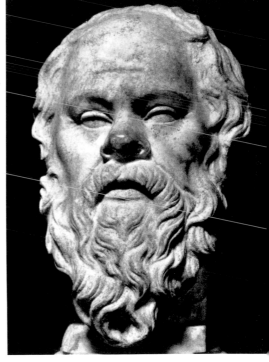

31

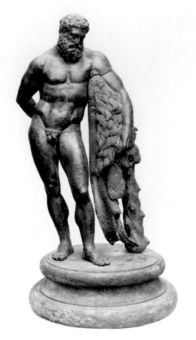

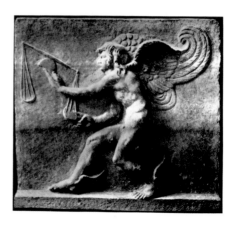

44. Small Roman bronze after Lysippos' *Weary Herakles*, the so-called *Farnese Herakles*. Paris, Louvre.

45. *Kairos*. Turin, Museo Civico.

the Bow, known in many copies and variants, is in proportion and modeling one of the finest Greek images of a growing child (fig. 46). The well-known *Aphrodite* from Capua has a comparable open stance, and the original may well have been his work—its popularity in antiquity is attested by the numerous copies.

Lysippos' work par excellence, the *Apoxyomenos (The Scraper,* fig. 47), curiously survives in only a single complete replica now in the Vatican and a very fragmentary torso. The original bronze was put on public display in Rome by the emperor Augustus' friend and son-in-law Agrippa. Later the emperor Tiberius loved the statue so much that he set it up in his private apartments, restoring it to public view only after a mob demonstration.

Another of Lysippos' athletes (best copy is in Berlin) is very youthful. Yet another has probable portrait features (head in Copenhagen, fig. 48). Portraits other than those named in ancient writings have

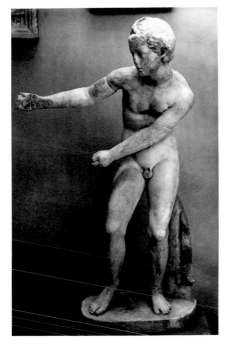

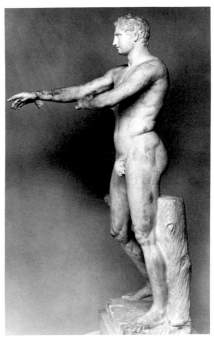

46. *Eros Stringing his Bow.* Roman marble copy. Ostia Museum.

47. *Apoxyomenos.* Roman marble copy. Vatican Museum.

been attributed to Lysippos by archaeologists, among them the *Aristotle* (see figs. 49 and 66, 67 below) originally dedicated by Aristotle's pupil Alexander, and a *Euripides* (fig. 68 below), the most tragic of the tragic poets, an inspired man who knew the bittersweet indifference of things. Both surely date from the late 30's of the fourth century. The late epigram already mentioned states that Lysippos put an image of the legendary fabulist Aesop at the head of the series representing the Seven Wise Men. This suggests that all seven portraits may have been created by the master himself, for example figure 69 below, possibly of Solon.

By the late 430's, Lysippos was already in the service of Alexander. After the first big battle of Alexander's conquest of the Persian Empire in 334 B.C., at the river Granicus, Lysippos was commissioned to make a group of the *Hetairoi,* the closest companions of Alexander, who fell rescuing him from peril. Sometime in the following years,

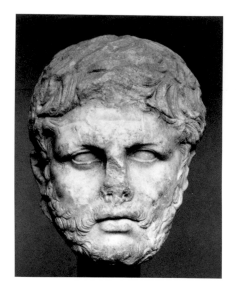
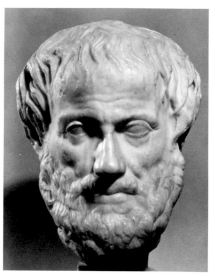

48. **Portrait of an athlete.** Roman marble copy. Copenhagen, Ny Carlsberg Glyptotek.

49. **Portrait of Aristotle.** Vienna, Kunsthistorisches Museum.

Lysippos may have worked for a time on the island of Rhodes. He then rejoined Alexander's entourage and may have stayed until Alexander's death in 323.

Afterward he returned to Greece. Perhaps as early as 322 he made an image of an Athenian that was dedicated in Olympia. Krateros, a companion of Alexander, ordered from Lysippos a group representing Alexander hunting a lion on an occasion when Krateros had saved his life (fig. 50). The group was consecrated at Delphi by Krateros' son Krateros, and we are told that Leochares, an established Athenian sculptor, cooperated in its execution. Does this mean that Lysippos was too old to finish the work? Not necessarily: Michelangelo remained at work in his eighties until his very last days. We also hear that about 316 Lysippos was commended by Kassandros, ruler of Macedon and an enemy of Krateros, for designing a new type of amphora for Kassandreia, a city founded by this prince. The portrait of Seleukos already mentioned would have dated still later, from the very end of Lysippos' career.

When Alexander called on Lysippos, he must already have been established as a great master. With some exaggeration, ancient tradi-

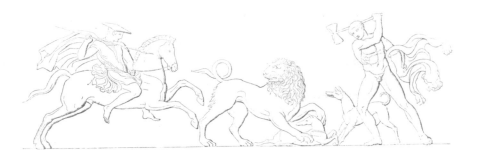

50. Alexander and Krateros hunting. Drawing after a relief in the Louvre echoing the monument by Lysippos and Leochares in Delphi.

tion maintains that the young king refused to have his portraits modeled by anybody else. Although there are portraits of Alexander by other artists, many of them can be related to Lysippos. These included the bronze of the young Alexander that the emperor Nero later gilded. An equestrian statue of Alexander by Lysippos is said to have had its features altered into those of Caesar. The most famous of the Alexander portraits represented the young ruler with a lance. It survives only in small reproductions and variants which give only a reduced, unsatisfactory idea of the lost original (fig. 51). Even so, one can perceive how tension erupts on the surface of the statue and that the face clearly portrays an individual. On the basis of other portraits of Alexander, the head preserved on the inscribed herm found in Hadrian's Villa at Tivoli (fig. 52) is universally accepted as giving the full-scale idea of Lysippos' portrait, both in conception and in style. This may be true, and the copy may be correct; but there is little if any art in it. The mediocre execution by an unpretentious craftsman reflects little of Lysippos' art and still less of how he interpreted the fascination of Alexander's personality.

This is only a partial list of what is either mentioned by ancient sources or pieced together by industrious archaeologists. Still, the task of identifying the 1500 works attributed to Lysippos has established a rather large base from which an idea can be formed of Lysippos' style. Of those works not surviving in full-size replicas, but reflected in small-scale statuettes, an outstanding statuette of *Poseidon* in Munich (fig. 53) may be cited. The art and the spirit fit well with Lysippos' oeuvre.

We are told that Lysippos claimed two teachers: nature and the statue of the *Doryphoros* by Polykleitos (fig. 54). The artist appears thus to accept tradition and to renew it. Indeed, the *Doryphoros,* a calm, impersonal image of a nude man carrying a lance, was called the *Kanon.* Polykleitos had glorified in the *Doryphoros* the ideal citizen of the Greek city state. The *Kanon* provided the law of proportions for generations of Greek sculptors. "Nature" as a teacher surely meant a richer view of reality, not copying it but finding in it elements which corresponded to and expressed a new world view. Like his contemporary Aristotle, who systematized knowledge of nature and history, Lysippos went to nature for wisdom, not for appearance. His anatomy is richer in details than Polykleitos'. His psychology runs the full gamut of emotion and expressions, and he himself, we are told, said that he represented men not as they were, but as they appeared.

This, of course, is an illusion of the epoch in two ways. Classical statuary before Lysippos was not fashioned closely after nature. It incarnated instead the ideal of the citizen expressed as physical fitness and beauty. The art of Lysippos' age portrays much more of man, not just his appearance but also his psyche, will, and emotions. The ideal is no longer of a perfect member of a perfect community but of an individual engaged in the conquest of the universe in the spirit of Alexander. One can say that Lysippos' art reflects the fourth century crisis of the Greek city states and their final elimination by the Macedonian monarchy. This was followed by the political and cultural expansion of Greece over the immense Persian Empire, opening a syncretism that nourished the old and new in all Greek traditions.

Ancient tradition acclaimed Lysippos first for extremely fine execution of detail, and the highest praise was addressed to his fine chiseling of hair (see fig. 13 above). He changed the Polykleitan *Kanon:* heads were now smaller; from chin to hair is 1:10 of the whole statue, the complete head 1:8. Also his proportions and stances were more subtle and richer in details. The statues no longer gave Polykleitos' general impression of squareness, but rather in the whole and in details a sense of gentle elongation. Lysippos was also praised for giving soul to his creations so that they reflect general and individual psychology, emotions, and fleeting expressions. A Latin poet, Propertius, said that the glory of Lysippos was *animosa effingere signa,* to create statues with soul. Parallel to this is a statement from a Greek source saying that he made images that lived, missing only actual breathing and movement.

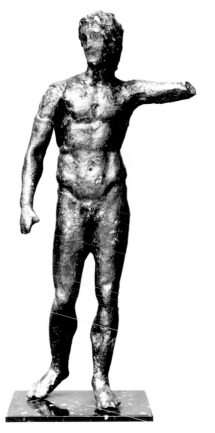

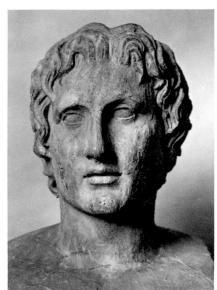

51. *Alexander with the Lance.* Roman small bronze. Paris, Louvre.

52. *Alexander Azara.* Roman marble herm from the villa of the emperor Hadrian at Tivoli. Paris, Louvre.

We are told that Lysippos' brother Lysistratos was the first to make casts of living faces. This seems to be reflected in the portraits connected with Lysippos. Are they more realistic than earlier portraits? Yes, in the sense that they show more of the sitters' personalities but not necessarily in that they show more of their actual likenesses. If we compare the oldest portrait of Socrates created soon after his death, with the one attributed to Lysippos (fig. 43 above), there is indeed much more of the actual appearance in the first but nothing of Socrates' *daimonion,* nothing of what made the Delphic oracle

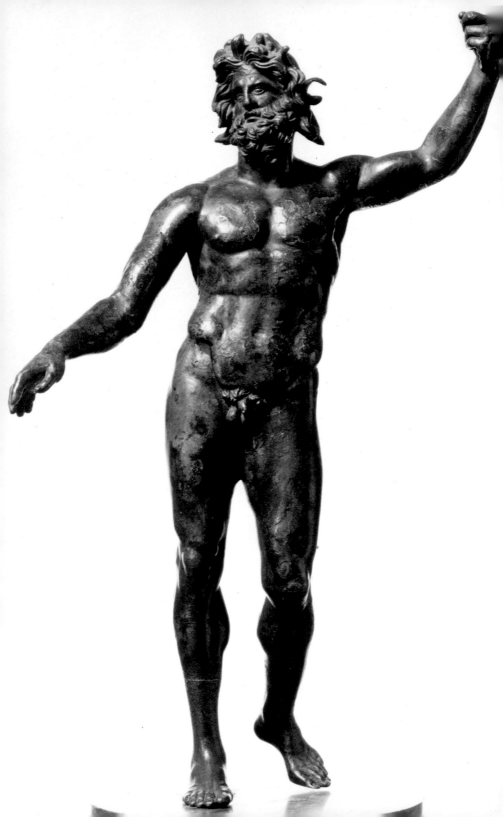

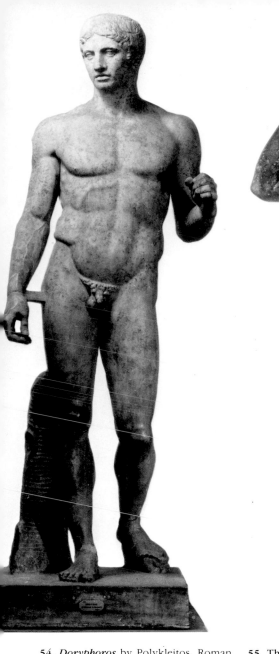

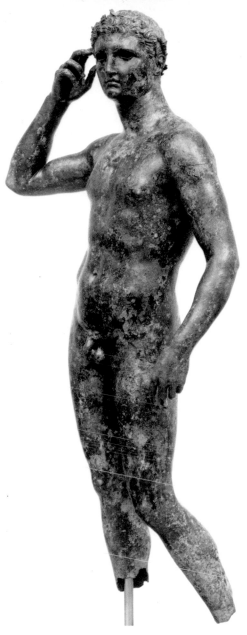

54. *Doryphoros* by Polykleitos. Roman copy from Pompeii. Naples, National Museum.

55. The *Getty Bronze*.

53. (left) *Poseidon Loeb*. Hellenistic bronze statuette. Munich, Museum antiker Kleinkunst.

proclaim him the wisest of living men. This early Socrates is just the husband of Xanthippe; it is the Lysippic one which changes his satyr-like appearance into the divine.

Of course, Lysippos uses the traditional ideal of *kalos kai agathos,* "beauty and breeding," but he gives it new meaning; instead of suggesting equality to gods, a real apotheosis takes place. Alexander raises his head above other mortals toward his equals on Olympus. The *hygrotes,* the moist eyes which had always been the attribute of Aphrodite in poetry and in statuary since the mid-fourth century, assumes in the face of Alexander the divine legitimation of the ruler. The parallel with Achilles claimed by Alexander early in his life was thus replaced by pretension of direct descent from the gods, a concept coming from the Orient. Through Greek tradition and through Lysippos' works, the ruler is not only placed above his fellow humans but he is also an inspiration to each of them.

Concluding the classical tradition in many ways, Lysippos also pointed the way for Hellenistic sculpture. His school, starting with his three sons and many pupils, represents the first period of Hellenistic art. In many respects the original bronze statue of a *Praying Boy* by Boidas, Lysippos' son, in the Berlin Museum (fig. 56) offers an interesting comparison with our statue. Teisikrates, a pupil of one of Lysippos' other sons, made several portraits of the first generation of Hellenistic rulers. The most famous was of Demetrios Poliorketes with little bull horns above the forehead, a purely Oriental inspiration as part of the paraphernalia of the ruler. A copy of this work was found in the Villa dei Papiri (fig. 37). Another pupil, Chares, was the author of the famous gigantic *Helios* that stood over the port of the city of Rhodes. A follower, Eutychides, created the personification or *Tyche* of the city of Antioch-on-Orontes, and the head of the river god Orontes is again a good parallel for the *Getty Bronze* (see fig. 57).

Establishing the *Getty Bronze* as a work of Lysippos is hampered by the lack of other originals, but the general parallels can be well traced. The stance and proportions of the *Getty Bronze* correspond well to the contemporary marble replicas of the Thessalian ex-voto in Delphi. It seems, therefore, that works of the middle of Lysippos'

56. *Praying Boy* by Boidas (the arms are modern restorations). Berlin, Staatliche Museen.

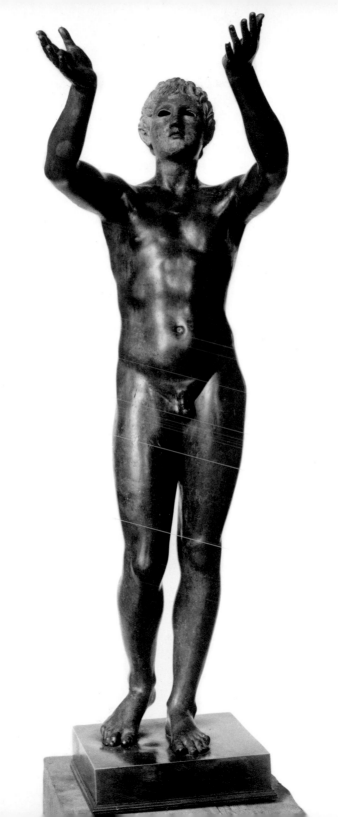

career are similar in general features and stance to our statue, but this does not fix its chronology.

An apt comparison for the head is a marble herm found in Lucus Feroniae, fifteen miles from Rome, with the head of an athlete who looks in many respects like an older brother of our prince (figs. 58 and 59). The similarity extends to the psychology and to the creation of an individual from an ideal type. Of course, the herm is a replica reduced from a complete statue; the subject is a young man older than ours, and the bruised ears identify a boxer. The original has been dated earlier in Lysippos' career, but its close affinity with the head of the *Apoxyomenos* (fig. 60) points rather toward its end. To the same period, another athlete surviving only in two replicas of the head (the far better one in Copenhagen; fig. 35) may be assigned: he too is very close to the original of the Lucus Feroniae monument.

Considered as a whole statue, the *Apoxyomenos,* perhaps most characteristic of all the works of the master, reveals more differences than similarities with our piece. Although not precisely frontal, the *Getty Bronze* is definitely fixed in space. We could easily visualize it in a group, not subordinated but equal, as in the dynastic monument of the Thessalian ruler. The *Apoxyomenos,* on the other hand, seems to rotate freely. The classical aspects of the *Getty Bronze* do not yet reach the level developed in the works of Lysippos' pupils and followers.

Lysippos came from Sikyon, and early in the fourth century a painter was active in this city, who may have some relevance for the *Getty Bronze.* His name was Eupompos, and one of his most famous works may be reflected in a Roman fresco (fig. 61). It represents a seated woman staring at a young athletic victor who is holding a palm branch in his left hand while his right has just placed an olive (?) crown around his brows. The striking affinity with the *Getty Bronze* was observed first by H. Herzer and more recently (and independently) by Professor Paolo Moreno. The Roman fresco was never a masterpiece and is today rather poorly preserved, but the *Getty Bronze* finds here its nearest kin. Like Lysippos, Eupompos claimed nature as his only teacher. Perhaps the work of the painter provided some inspiration for the young sculptor, remaining alive in his memory and work even in his mature years.

Lysippos also claimed another teacher—Polykleitos—and among Polykleitan sculptures there is a youthful figure that was cast as the image of a very young victor. This is called the *Dresden Boy* (after

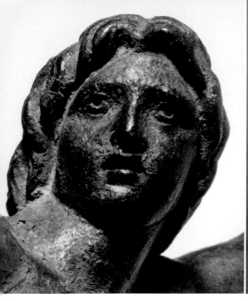

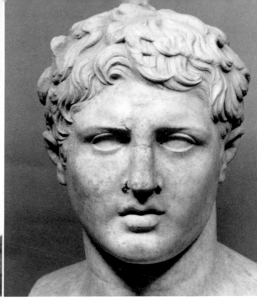

57. Head of the river god Orontes. Detail of a small Roman bronze after Eutychides' group of the *Tyche of Antioch-on-Orontes*. Collection of William and Constantina Oldknow.

58. Roman marble herm from Lucus Feroniae. Scorano, Museo Civico.

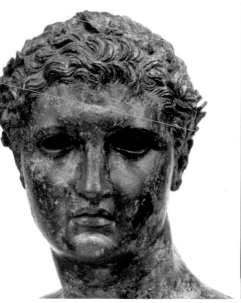

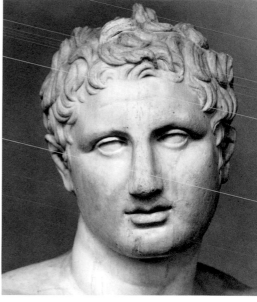

59. The *Getty Bronze*.

60. Head of the *Apoxyomenos* (see fig. 47).

43

the best known copy, fig. 62) and is usually attributed to the school of Polykleitos at the end of the fifth century. Comparison with the *Getty Bronze* and with the male figure of the fresco shows how differently the same subject could be treated so close in time in Greek art. The *Dresden Boy* is stout and sturdy, solid, with a fine balance in proportion and stance. He faces the spectator. The work of Eupompos and still more of Lysippos open a new universe, clearly separating the world of the viewer from the interior, independent existence of the artistic representation.

Ancient Greek art thus bore the stamp of Lysippos forever. In the late second century B.C. the neo-Attic sculptor Boethos cast the figure of *Eros Enagonios* (fig. 5), also rescued from the Mediterranean. A less experienced eye might consider him as a younger brother of the *Getty Bronze*. The *Eros* reproduces the same proportions and stance; there is even a marked relationship in the face. Closer examination, however, shows that what was life in Lysippos has become a highly cultivated but dried up schema. The body of the *Eros* seems to follow a spiral in space, but the organic feeling and the tangible presence of the *Getty Bronze* are irretrievably lost. In some respects the most appropriate comparison to the *Getty Bronze* is the *Alexander with the Lance* (fig. 51 above). At first one registers the differences: the *Alexander* is open in movement and contour while our statue is more closed in on itself with a contained silhouette. But the spirit is the same: the momentum of a young eagle ready to fly.

61. **Fresco of an athlete crowning himself.** Roman copy after an original by Eupompos. Naples, National Museum.

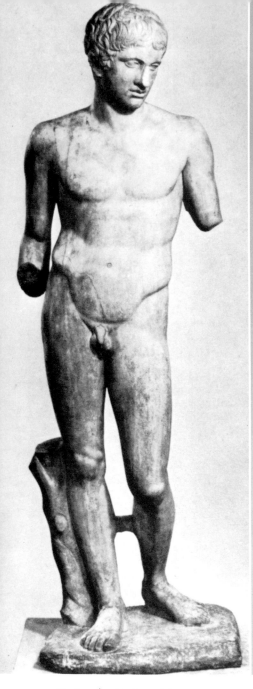

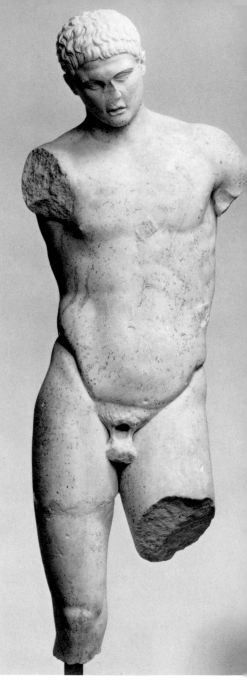

62. *Dresden Boy* by Polykleitos. Dresden, Skulpturensammlung.

63. Athlete pouring oil into his hand. Roman marble copy. Malibu, The J. Paul Getty Museum (73.AA.3).

Lysippos
in the Getty Museum

Other works that reflect the creations of Lysippos and his school are on display in the Getty Museum. They are, of course, all Roman copies. Most translate bronze originals of the master by more or less mechanical means into marble, necessitating the introduction of secondary supports.

To the earliest period of Lysippos' career belongs a statue of an athlete who was pouring oil from his raised right hand into the left palm which was held close to his stomach (fig. 63). It is probably a copy from the end of the first century A.D., while the original could date around 360, contemporary with the *Herakles* best preserved in a replica in Copenhagen.

The *Eros Testing the Bow* (fig. 46 above) is recalled by a head (fig. 64), in rather poor condition, which had an unconventional destiny. Usually a modern head was used to repair an ancient body; here the genuine antiquity was oddly and amusingly set on a late Baroque angel from about 1800 (?) to improve its appearance.

Lysippos' work included many honorary statues of great men from his own times and the more remote past. From his portraits, popular with the Romans, the museum has three very different examples of his portrait of Aristotle. A correct marble replica corresponds well to the general type preserved in many other copies (fig. 65). A head in light basalt from the Syrian region of the Hauran shows how under the *pax romana* the reputation of the Greek classic authors spread throughout the Roman world (fig. 66). The work is simplified, but the man is still easy to recognize. There is still less of Aristotle and nothing at all of Lysippos in the third example where Aristotle is coupled with his teacher Plato (fig. 67): a provincial craftsman from Egypt carved a fencepost terminated by a fashionable reflection of the great men.

The portrait of Aristotle is usually compared with Lysippos' version of the tragic poet Euripides, perhaps the best portrait creation of classical Greece (fig. 68). The two portraits share, besides some external features like the attempt to conceal a receding hairline by strands of hair combed forward, a deep psychological insight. Pedagogical

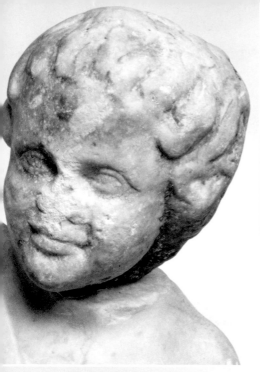

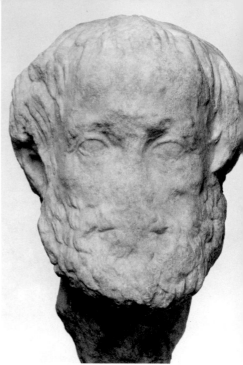

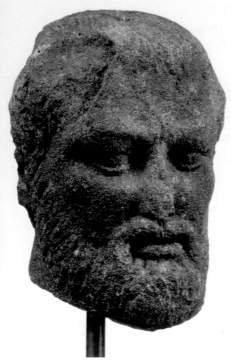

64. **Head of Eros** (see figure 46). Roman marble copy. Malibu, The J. Paul Getty Museum (71.AA.367).

65. **Portrait of Aristotle**. Roman marble copy. Malibu, The J. Paul Getty Museum, anonymous loan (L79.AA.26).

66. **Portrait of Aristotle**. Roman provincial copy in Haurân basalt. Malibu, The J. Paul Getty Museum, anonymous donation (75.AA.105).

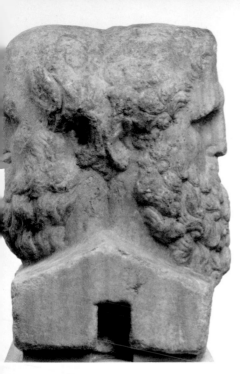

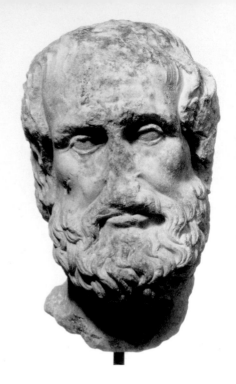

67. **Double herm**: Plato and Aristotle. From Egypt. Malibu, The J. Paul Getty Museum (74.AA.15).

68. **Portrait of Euripides** (see also figure 49). Malibu, The J. Paul Getty Museum (79.AA.133).

69. **Portrait herm of Solon** (?). Said to be from Corfu. Malibu, The J. Paul Getty Museum (73.AA.134).

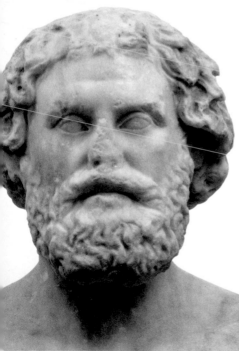

and self-conscious for the *Aristotle,* the vision becomes introspective and passionate for the *Euripides.* The Getty replica of the *Euripides* is of outstanding sculpture quality, but not as faithful for the portrait features as other copies. Its Greek sculptor (it is said to come from the East Greek island of Lesbos) was less concerned with accuracy than with his own taste for good modeling.

Lysippos probably met Aristotle and thus knew his appearance; and he could use at least a tradition about the likeness of Euripides preserved in older images. The third Lysippan portrait in the Getty Museum is of a completely different type (fig. 69). It represents, according to most archaeologists, the Athenian statesman Solon, who in the early sixth century B.C. contributed equally to politics, business, poetry, and philosophy. If it is not he, it is another of the semi-mythical Seven Wise Men of ancient Greece. It is a good example of the *non traditii vultus,* the recreation of the likenesses of great men by artists expressing the nostalgia of the Greeks for their past greatness. All three portraits seem to date in the 330's; the *Solon* possibly even in the late 320's.

There are good examples from Lysippos' late work in the Getty Museum. Thanks to the generosity of the Los Angeles County Museum of Art, visitors to the museum can admire the marble *Lansdowne Athlete* (fig. 70) which harks back to a bronze original contemporary with or slightly later than the *Apoxyomenos.* It has the same complicated stance, and creates a statue perfectly in the round, meaningful in every view. A replica of the torso exists in Athens, but the new restoration in the Getty Museum laboratory in 1980, suppressing the last vestiges of the eighteenth century restorations, brought the statue an unexpected glamor.

The famous *Farnese Herakles* is represented by a tiny ivory carving that conveys the motif and the general proportions (fig. 71). The bigger marble statuette of a similar type (fig. 72) displayed together with it is not ancient, nor can it be called a true forgery. It is instead a late sixteenth century Italian emulation of antiquity. The anonymous Renaissance sculptor wanted to show that he could do as well if not better than Lysippos, imitating preserved classical sculptures so faith-

70. The *Hope Athlete.* Roman marble copy. Los Angeles, Los Angeles County Museum of Art, William Randolph Hearst Collection (49.23.12).

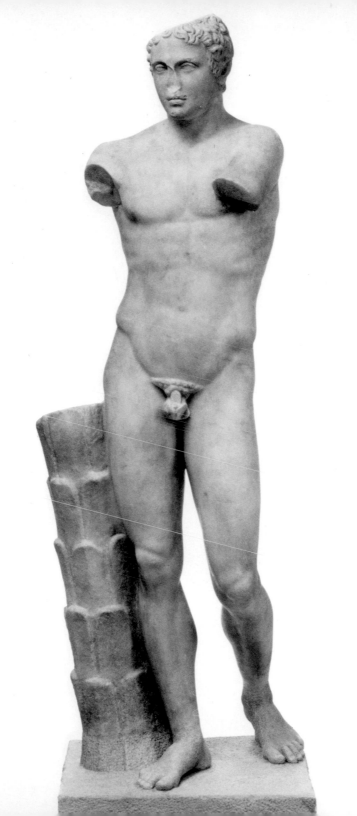

fully that he included artificial breaks. Two small ancient bronzes (figs. 73 and 74) also reproduce the colossal original of the *Farnese Herakles.* Another very small bronze shows the tired, seated Herakles, originally described as having been made small scale to set on a banqueting table: the *Herakles Epitrapezios* (fig. 75); the original is said to have belonged successively to Alexander, Hannibal, Sulla, and another Roman.

The very last piece of Lysippos in the Getty Museum invites comparison with the *Getty Bronze.* It is a Hellenistic variant of the *Alexander with the Lance* (fig. 76). Working in the second century B.C., the sculptor altered the orientation of the original sculpture (see fig. 51) to make it exclusively frontal, but he kept the proportions and the finesse of the modeling. Reducing Alexander's thrust of irresistible energy, both physical and spiritual, he turned back to a classical stability. The raised right arm is now broken; it must have been worked separately as was the left one parallel to the body. In the upper left rib area, a pentimento can be traced where the sculptor was obliged to carve slightly more deeply to fit the lower arm in position. The head is very nice, but the leonine spirit of the new Achilles is sought in vain despite the obvious Greek carving.